WHITSTABLE & HERNE BAY PUBS

JOHNNY HOMER

AMBERLEY

This book is for Harriet and Lydia.

First published 2016

Amberley Publishing
The Hill, Stroud
Gloucestershire, GL5 4EP

www.amberley-books.com

Copyright © Johnny Homer, 2016

The right of Johnny Homer to be identified as the Author of this work has been asserted in accordance with the Copyrights, Designs and Patents Act 1988.

ISBN 978 1 4456 6115 5 (print)
ISBN 978 1 4456 6116 2 (ebook)

All rights reserved. No part of this book may be reprinted or reproduced or utilised in any form or by any electronic, mechanical or other means, now known or hereafter invented, including photocopying and recording, or in any information storage or retrieval system, without the permission in writing from the Publishers.

British Library Cataloguing in Publication Data.
A catalogue record for this book is available from the British Library.

Typesetting by Amberley Publishing.
Printed in the UK.

Contents

	Maps	4
	Introduction	6
Chapter One	Whitstable and Seasalter	9
Chapter Two	Chestfield, Swalecliffe and Tankerton	48
Chapter Three	Herne Bay	63
Chapter Four	Beltinge, Broomfield and Herne	86
	Acknowledgements	96

Whitstable

1 Duke of Cumberland	2 Pearson's Arms	3 Prince Albert	4 The New Inn
5 The Quayside	6 Hotel Continental	7 Royal Naval Reserve	8 Smack Inn
9 Wall Tavern	10 Old Neptune	11 Black Dog	12 Twelve Taps
13 Ship Centurion	14 The Peter Cushing	15 Coach and Horses	16 The East Kent
17 Handsome Sam	18 Two Brewers	19 The Long Reach	20 Rose in Bloom
21 Oyster Pearl	22 The Sportsman	23 The Monument	24 The Marine
25 Tankerton Arms	26 The Royal	27 The Wheatsheaf	28 Oyster Bed
29 Chesterfield Barn	30 The Plough		

Herne Bay

31 Hampton Inn
32 The Heron
33 Saxon Shore
34 Divers' Arms
35 The Ship Inn
36 Rodney's Sports Bar
37 Bouncing Barrel
38 Prince of Wales
39 Druid's Head
40 Rose Inn
41 Four fathams
42 Firkin Frog
43 Rising Sun
44 Copper Pottle
45 Butcher's Arms
46 Smugglers' Inn
47 Huntsman & Horn

Introduction

Whitstable and Herne Bay are seaside neighbours, barely five miles apart as the crow flies. They are both towns brimming over with history, colour and characters. They both have the sea at the heart of their past and, in all probability, their future. And they are both excellent places for those who love the Great British pub, in all its many splendored colours. The aim of this book, then, is to look at those pubs, at both their past and their present.

For several years, I was the sports editor of a series of weekly East Kent newspapers, among them the *Herne Bay Times* and the *Whitstable Times*. Although the two towns are relative minnows as far as the county football scene is concerned, the derby fixture between them was, and indeed remains, one of the most keenly contested in Kent.

As a local newspaper journalist, and a local newspaper sports journalist at that, my search for a story often led to the saloon bar or boisterous post-match pub. Where there is football there is usually beer, and despite the best efforts of the neo-prohibitionist it will always be the way. I am then, I feel, well qualified to write this book.

Changing Fortunes

Despite all that they have in common, and a treasure trove of good pubs is certainly one of them, these days Herne Bay and Whitstable are very different towns.

Whitstable is now a byword for the alternative British seaside holiday. You'll struggle to find a 'Kiss Me Quick' hat in the 'Bubble' – as locals affectionately refer to the town after it featured many years ago in a television advertisement for the chocolate bar Aero – but you will find enough artisan olive oil to float an oyster yawl on. Oh, and Whitstable has oysters too, tonnes of them in fact.

Whitstable, once a working town with a busy harbour and very much the poor relation to Herne Bay, is now famous for being one of the most fashionable towns in Britain and has been dubbed 'Islington-on-Sea' by more than one national newspaper. But most of all it is famous for its oysters, which have been cultivated off its coast since Roman times. It still has a working harbour, too.

In Whitstable even the street artists celebrate the town's love of good beer.

By contrast, Herne Bay was one of the earliest seaside resorts in Britain. It grew rapidly throughout the nineteenth century as a place where people came to swim and take the healthy (and often bracing) sea air. When the railway arrived it became even more popular, grand hotels and more modest guesthouses cropping up as the town thrived.

But times have changed and, as with every other resort in the country, once the great British public developed a taste for foreign travel, the domestic holiday market suffered. Today, Herne Bay is still a popular seaside destination with a seafront that still boasts amusement arcades, crazy golf and even the odd stretch of sandy beach, but it is clearly not what it once was.

Micropub Revolution

The pubs in Herne Bay, Whitstable and their immediate environs have also changed with the times. Almost inevitably many watering holes have closed, although in recent times this seems to have all but stopped in Whitstable with the notable exception of the dear old Four Horseshoes on Borstal Hill. The Bay has not been so lucky, and the Bun Punny, the Richmond, the Royal Oak and the Queen Victoria are all relatively recent casualties.

Micropubs like the Tankerton Arms have changed the pub landscape.

But while a staggering number of traditional pubs continue to close each week across the United Kingdom, the continued rise of the micropub shows that there is life in the British boozer yet.

Micropubs, for the uninitiated among you, are small pubs based in premises that once housed the likes of pet food shops or kitchen showrooms or, in the case of the excellent Tankerton Arms, a tattoo parlour. They sell cask ale, predominantly from Kentish microbreweries, and are free of televisions, gaming machines and muzak. Mobile phones are not encouraged. The idea is that you visit your local micropub to sup ale and talk.

The first ever micropub, the Butcher's Arms in Herne, opened in 2005 and was the brainchild of Martyn Hillier. It is fair to say that his revolutionary idea, an idea that marks a return to basics, has changed the pub landscape not only in Kent, but across the United Kingdom.

Not surprisingly the phenomenon has thrived in Herne Bay, which has the Bouncing Barrell and the Firkin Frog, and Whitstable, which can boast the Black Dog, Handsome Sam and the wonderful Tankerton Arms.

All things considered, these are great towns with great pubs. Long may it stay that way.

Chapter One

Whitstable and Seasalter

DUKE OF CUMBERLAND, High Street

There are a handful of pubs synonymous with Whitstable, and the grand old Duke of Cumberland, which stands where Harbour Street and Sea Street meet at the start of the High Street, is without doubt one of them.

Today's pub is certainly a striking one, an imposing piece of boisterous Victoriana that dates from 1878 and enjoys Grade II listing. It stands on a prominent site in a part of town known by some locals of a certain vintage as the Cross. There has been a tavern

The Duke of Cumberland is a busy town centre pub. (Shepherd Neame)

of one sort or another here for at least 300 years, certainly since the early eighteenth century, when it went by the name of the Noah's Ark.

It had been changed to the Duke of Cumberland by 1748, reflecting no doubt the popularity of George II's son, who had routed the Scots at the Battle of Culloden two years earlier.

For much of its history the pub was also the de facto town headquarters of Whitstable's oyster dredgermen, who certainly seem to have been a thirsty bunch. They would have visited the old Duke at the end of the working day to collect their wages, a fair proportion of which almost certainly returned immediately over the bar.

Fire and Rebuilding

Whitstable had long been susceptible to fire, and when the flames took hold of a number of buildings in and around the Cross in 1866, the old Duke of Cumberland perished in the flames, as did the Red Lion to the rear. The Red Lion was never rebuilt and is today commemorated by Red Lion Lane, but the Duke did thankfully rise slowly from the ashes.

Shortly after its 1878 rebuilding, the pub was bought by Shepherd Neame, alongside a number of other Whitstable hostelries, and was much expanded by the Faversham company into a 'family and commercial' hotel. Rooms are available to this day. Early in the twentieth century a grand billiard room was added and also stables to the rear.

After a period when the pub seemed to lose direction a little, since October 2014 it has discovered a new lease of life and has been effectively reinvented as one of Whitstable's most fashionable and bohemian venues thanks to the team of Tony Tarrats, Sarah Smith and Annie Foreman. They were previously behind the trendy

Opposite and right: The Duke of Cumberland was built in 1878. (Shepherd Neame)

Windy Corner stores in Nelson Road and also the acclaimed Salt Marsh restaurant, formerly in Oxford Street. Salt Marsh is now based in the Duke's former stable block.

The pub has become a major live music venue, with bands playing in the former billiard room. It has changed the atmosphere here completely, and to drop in at the weekend is to suddenly find yourself in Hoxton-on-Sea. Well, kind of.

PEARSON'S ARMS, Horsebridge Road

Today's Pearson's Arms is a swish and ever so slightly upmarket gastropub, which has 'celebrity' chef Richard Phillips overseeing operations. Located close to the Horsebridge, just yards from the beach, its exterior of white weatherboarding is old Whitstable defined while the shabby chic of the interior very much reflects at least one side of the town today.

However, this well-appointed old pub's long history can boast a few dark chapters down the years, with suicide, drunkenness and what a police report in the late nineteenth century described as 'loose women' all involved.

The Pearson's Arms originally stood on Tower Parade, where today you'll find the Wynn Ellis Almshouses. It was opened by Charles Pearson junior in the early 1830s. In 1828, he inherited a substantial estate after the death of his father, Charles senior, who had made his fortune from the copperas industry, which thrived for many years in Tankerton. Copperas was a local mineral that, once processed, was used in textile

Pearson's Arms at the Horsebridge.

dyeing. What is today known as Whitstable Castle was built by Pearson senior as the family's grand Kent home.

Pearson junior's original Pearson's Arms was a speculative project built in the hope that when the railway arrived in Whitstable the line would be driven to the nearby beach. Instead, Whitstable Harbour was constructed and the Tower Hill pub proved a failure.

The Suicide of George Cocks

In the late 1840s, the Pearson's Arms was resurrected at its current location in what was previously the Whitstable Arms, occupying a small cottage, parts of which can be seen to the rear.

The pub was popular with the dredgermen who worked nearby – thirsty work dredging is – and was also a hang out for smugglers, who thrived in Whitstable.

Canterbury brewer Ash and Co. owned the pub in the 1860s, but it seems to have acquired a bad reputation. Apparently, the landlord did not only like a drink himself, but he encouraged the aforementioned 'loose women' and for a time in 1864 the pub's licence was withheld.

The pub's sign still features the Pearson family's coat of arms.

The pub's darkest hour came in 1881, when landlord George Cocks was found head down in a water butt. Although attempts were made to revive him, he was already dead, and at an inquest held soon after, a verdict of suicide delivered by the East Kent coroner.

It was later revealed that Cocks's relationship with his wife was a troubled one. Apparently, Mrs Cocks was not averse to waving a knife in his general direction. He, it seems, was driven to take his own life.

The Pearson family's coat of arms still adorns the pub sign. The motto in Latin reads *Perduret probitas*, which translates as 'Integrity endures'.

PRINCE ALBERT, Sea Street

The Prince Albert these days is in many ways a typical Whitstable pub, attracting a predominantly young and 'fashionable' clientele who pack it out at weekends to drink craft and cask ale, sip bespoke gin and sample food from so-called 'pop-up' menus.

But this was, like many pubs in the town, once the refuge of those employed in some of Whitstable's heavy industry, such as dredgermen, seafarers and those working on the carts that operated out of the old Horsebridge opposite.

It's an old pub too, and we certainly have records of a licence to sell ale being held here as early as 1858. It was originally weatherboarded in the traditional local style, and for many years operated by the famous old Canterbury brewer Flint and Co. When

The Prince Albert, Sea Street.

it was acquired by Shepherd Neame, the Faversham company rebuilt it, which is the brick structure we still have today.

At some point, however, it seems to have fallen into the hands of the Ramsgate company Tomson and Wotton. Alas, two rare pub windows from those days, monogrammed with the brewer's famous 'T&W LD' logo seem to have sadly disappeared.

For a period in the 1990s it went by the name of Alberre's, when the pub's sign featured the colours of the French tricolour.

Lord Haw-Haw

One of the most-often repeated pieces of Whitstable mythology concerns the fascist quisling William Joyce, or Lord Haw-Haw as he was disparagingly known, who some maintain spent a year before the outbreak of the Second World War living in Whitstable, where he earned a living running a radio repair shop.

While it is certainly on record that in 1936 Joyce addressed a pro-fascist meeting at the Forrester's Hall, which now houses Whitstable Museum, there seems to be no hard evidence that he spent any time actually living in the town.

The New Inn, Woodlawn Street (Shepherd Neame).

And there is even less evidence that he spent time drinking in the Prince Albert, a claim repeated in the 1993 book *Ales and Tales* by Messrs Pike, Page and Cann. It is easy to see how this supposed 'fact' might have been arrived at, for in both 1933 and 1934 the British Union of Fascists did indeed hold meetings near the old Horsebridge, just yards from the pub. Joyce, one suspects, didn't care much for English beer.

THE NEW INN, Woodlawn Street

During the mid-nineteenth century, Whitstable experienced a period of sustained prosperity that saw a variety of industries thrive and the population increase. To cater for this growing population new residential areas were developed, notably the myriad of narrow streets with their terraced houses to the south of the town centre.

These terraced houses were modest dwellings, designed to cater for those employed in industries such as fishing, the harbour, the emerging railways and, of course, building. Naturally, such heavy manual labour can be thirsty work, and so, in line with the construction of housing, a number of equally modest pubs were also built.

Of these the New Inn in Woodlawn Street was one of the earliest. Indeed, on the pub website today they make a claim to be 'the first purpose built pub in Whitstable'. These were unpretentious and functional drinking places, a refuge for the working man after a hard day's graft, and for many years they served their purpose admirably.

But the day of the humble backstreet boozer were numbered and, as detailed in *Ales and Tales*, once-popular taverns such as the Forester's Arms and the Horn of Plenty – both in Albert Street – and the Sovereign in Victoria Street closed long ago.

Last Backstreet Pub

The New Inn, then, can make a good claim to be Whitstable's last surviving backstreet pub, and in its own restrained way it is an attractive building. It claims a date of 1830 on its website, possibly a little too early; although it was certainly serving the working men of Whitstable by 1860.

It was originally called the Bricklayer's Arms, and the bricklayers in question were probably those working on the large-scale building going on in the surrounding streets. It was not uncommon for canny businessmen engaged in the development of an area to provide a place of refreshment for their workforce. It was also a good way of getting back some of the money they had paid out in wages.

The pub adopted the New Inn name in the late eighteenth century, probably around the time it was acquired by Shepherd Neame, and while every other backstreet pub has perished or been converted for residential use, it is still going strong, helped no doubt by its close proximity to the town centre and its long-held reputation for good beer. The pub is regularly included in *CAMRA's Good Beer Guide*.

The New Inn is a typical backstreet local.

The Quayside in Harbour Street was formerly the Railway Tavern.

QUAYSIDE, Harbour Street

Today's Quayside is a bustling and lively pub and the first that you encounter as you enter Whitstable from Tankerton. But don't be fooled by the big-screen sport and other accoutrements of today's modern pub, for this is an old watering hole with a colourful history.

The building that today houses the Quayside was originally built as a domestic property, but in the mid-nineteenth century a licence was secured to sell ale by a chap called Stephen Perkins.

Perkins extended the pub by buying adjoining properties but seems to have entered into a financial agreement with the Canterbury brewer Flint's to do so, and in the 1880s it passed into their hands, eventually ending up as a Whitbread house.

Crab and Winkle Line

Back then Whitstable Harbour was very much a working one and the Canterbury and Whitstable Railway, or the Crab and Winkle line as it is more commonly known, ran nearby. Hence the pub was originally and for many years called the Railway Tavern.

The Crab and Winkle line stopped running in 1952, and in 1958 the Railway Tavern became the Punch Tavern. Why it was named the Punch Tavern is unclear, but it would appear that the conceit of changing historic pub names at the drop of a hat is nothing new.

For many years the pub has been known as the Quayside, a name that, given its close proximity to the harbour, at least makes some kind of sense.

Hotel Continental, Beach Walk.

HOTEL CONTINENTAL, Beach Walk
The Hotel Continental is one of Whitstable's most fashionable places to stay, but the reason I include it in this book is because its ground-floor bar and bistro is, to all intents and purpose, the taproom for the Whitstable Brewery.

The building itself dates from the late nineteenth century and given its beachfront location, and hence exposure to the changeable East Kent weather, is sturdy in appearance rather than fancy. It replaced a previous wooden structure.

What is today the bar was for many years a café with a separate hotel, known as Beulah, located next door. The bar was also known as Harbour Lights for a time. The two separate entities were later combined to give us the Hotel Continental set-up we have today.

Whitstable Brewery
The Whitstable Brewery was started back in 2002, the brainchild of the Green family, who also have several other business interests in the town. When the old Swale Brewery based at Grafty Green near Maidstone came up for sale, they took the plunge and haven't looked back since.

Under the watchful eye of Rafik Abidi, who formerly worked for Shepherd Neame, they produce some excellent cask ales, such as the acclaimed East India Pale Ale,

The Royal Naval Reserve, Whitstable High Street.

alongside some interesting keg offerings, which might loosely be termed craft beer, notably a raspberry wheat beer. The brewery's Oyster Stout, as the name suggests, is the excellent accompaniment to a plate of bivalve molluscs. Just remember to chew before you swallow.

Although the beer itself isn't brewed in Whitstable, the range produced fits perfectly with the town's modern seaside dynamic, and the bar of the Hotel Continental is the place to find perhaps the best representation of that range.

The current Whitstable Brewery should not be confused with the old Whitstable Brewery, which was located in Oxford Street, roughly opposite where today's public library stands. This was founded in the 1770s by local businessman John Saunders and was a thriving business for many years, supplying many local alehouses. In 1866 it was acquired by Canterbury's Northgate Brewery and promptly closed down.

ROYAL NAVAL RESERVE, High Street

The first time I visited Whitstable was in the early 1990s, and the first pub, of many I visited on that fateful day, was the Royal Naval Reserve. If memory serves me correctly, I drank a pint of Fremlins.

Apart from the fact that this former Whitbread house in now in the hands of Shepherd Neame, and as a result the beer on offer is different, very little else seems to have changed in the intervening years, from the old school interior complete with net curtains and chintz upholstery through to the friendly bustle of the downstairs bar.

Pub sign celebrating the Senior Service.

This remains one of Whitstable's great unspoilt pubs, refreshingly down-to-earth and old school in a town which can on occasion lapse into self-parody.

It is also one of Whitstable's oldest surviving pubs, as a glance at the peg-tile roof confirms. The bare bones of the current building date from 1760, and there are records of beer being sold here as early as 1840.

Change of Name

John Giles is noted as the landlord here in 1843, although at that point the pub was trading as the Rose, its original name. However, when he died suddenly in 1862, the flurry of legal activity that followed could have come straight from the pages of *Bleak House*, with some forty-five nieces and nephews claiming from his estate.

Old school rules inside the Royal Naval Reserve.

At that point the Rose fell into the hands of Faversham brewer Rigden's, who knocked through into one of the adjoining terrace properties to increase the size of the pub, as can clearly be seen from today's frontage.

The Rose changed its name to the Royal Naval Reserve in 1876. This was no doubt inspired by the fact that a few miles away in Seasalter the Royal Naval Reserve had a training battery, which had been established in the nineteenth century and was still being used into the twentieth century. It is just one of many pubs in this part of Kent to mark the area's naval connections in their choice of name.

The pub has long enjoyed a good reputation for the quality of its food, in particular its seafood, and its regular Friday night disco is the stuff of Whitstable legend.

THE SMACK INN, Middle Wall

If you really want to discover a place like Whitstable, to fully absorb its strangeness and quirk, you sometimes have to venture away from the town's main drag and explore its backstreets and alleyways.

This is particularly true of the area to the north of the High Street and Oxford Street. Walk down any of the half dozen or so narrow alleyways you will find at intervals, the likes of the intriguingly named Squeeze Gut Alley for instance, and you will find yourself in Middle Wall, strangely quiet after the hustle and bustle of the main drag and wonderfully atmospheric too.

Here you will find the Smack Inn, a lively local named after the traditional style of single-masted fishing vessel that would once have been very common in Whitstable and elsewhere throughout Kent. It seems an apt name for a pub that has surely been frequented by many a salty sea dog down the years, not to mention a few involved in Whitstable's once-thriving smuggling trade.

The Smack Inn, Middle Wall.

From Beerhouse to Inn

Middle Wall was reclaimed land upon which speculative building began in the late eighteenth century, and the original Smack started life around 1830, initially as a cottage where beer could be drunk. At the time an establishment such as the Smack, too humble to call itself an inn, was commonly known as a beerhouse and there were many of them in Whitstable.

The premises were extended by a former sailor called John Whorlow, who held the licence in the mid-eighteenth century, and in 1880 the Smack Inn, now a 'respectable'

The main bar of the Smack Inn.

pub, was bought by Shepherd Neame. This was a period of much expansion for the famous old Faversham brewer, who acquired several other properties in Whitstable around the same time and increased the size of the Smack Inn.

In the very early years of the twentieth century, the pub had a reputation that did not endear it to local authorities, and, possibly responding to pressure from said authorities, Shepherd Neame rebuilt the Smack as the attractive building we have today.

The pub has long enjoyed a reputation as one of Whitstable's more bohemian hang-outs and in March 2015 it reopened following a £100,000 refurbishment and with veteran licensee Chris Smythe installed at the helm.

Sadly, lost in this refurbishment were the many front pages from old editions of the *Whitstable Times*, which for many years enjoyed pride of place on the ceiling of the pub's main bar.

WALL TAVERN, Middle Wall

Most people who live or visit Whitstable are probably familiar with iconic pubs such as the Duke of Cumberland, Old Neptune or Ship Centurion, but surely the Wall Tavern speaks as much, if not more, about Whitstable's eternal dilemma, namely that of the town versus the sea.

The pub, like many in Whitstable, started life as a humble cottage from which ale was sold. This would have been around 1825. Building started in Middle Wall in the late eighteenth century upon land reclaimed from the sea, with Island Wall acting as the first line of defence. And so, the 'wall' honoured by the Wall Tavern is the one designed to protect the town from flooding, although not always successfully as the events of 1897 and 1953 illustrated.

Like the Smack just a short stroll away, the Wall Tavern became a bona fide licensed property at some point in the 1840s. Unlike the Smack, which was rebuilt in the

The Wall Tavern in Middle Wall.

early years of the twentieth century, the current Wall Tavern remains a traditional weatherboarded building, essentially the original cottage expanded and extended over many years. It enjoys Grade II listing.

Changing Pub Sign

The pub spent time under the ownership of Flint's of Canterbury and ended up in the hands of Whitbread. Today it is a free house and remains a popular watering hole known for live music and DJ sets.

We should be thankful that it is still with us at all for, like the Smack, it has ridden some choppy waters along the way. The poor old Alma, the third of the trio of pubs that once occupied Middle Wall, closed in 1911. It, too, was a Flint's establishment.

The Wall Tavern's pub sign has changed many times over the years and, in an odd way, reflected many of the changes that have gripped Whitstable itself. The sign once featured a fisherman, a salty old sea dog if ever there was one, standing on the sea wall, drinking beer and conversing with some animated-looking fish. For a thankfully brief period we had Kilroy, of 'Kilroy Was Here' fame, poking his nose over a bare brick wall.

The current pub sign depicts a bicycle leaning against the sea wall with sailing vessels and a number of colourful beach huts in the background.

In 2007, art collector Charles Saatchi paid a cool £75,000 to Tracey Emin for her Whitstable beach hut, although admittedly she had removed it from Whitstable, placed it in an art gallery and titled it *The Last Thing I Said to You Is Don't Leave Me Here*. It is not on record whether Saatchi has, or has not, ever sunk a pint or two at the Wall Tavern.

THE OLD NEPTUNE, Marine Terrace

Visiting Whitstable and not watching the sunset from the beach outside the Old Neptune is the pub equivalent of visiting Whitstable and not eating an oyster. There are some things that the first-time visitor to the Bubble, as Whitstable is affectionately known among locals, just has to do, and one of them is down a pint (or three) at the 'Neppy'.

In many ways this is the quintessential Whitstable boozer: old, bohemian, historical, often loud and always listing to port a little. Or is it starboard? Many local pubs have very strong connections with the sea; the Old Neptune is almost in it.

The generally held view is that the pub evolved from what was a boat workshop on the beach by Marine Terrace. It can get rather stormy at times in these parts, and in 1853 the then Old Neptune beerhouse was destroyed by a combination of an exceptionally high tide and strong winds.

Another storm in 1883 spared the pub but damaged a number of nearby vessels and took several lives, and the Neptune was called into use as a makeshift morgue. Four years later the old pub, wooden in construction and little more than a converted pair of cottages, was not so lucky and this time was virtually washed away in another raging tempest.

The Old Neptune is probably Whitstable's best-known pub. (Shepherd Neame)

Inside the Old Neptune, Marine Terrace. (Shepherd Neame)

Surviving Tomson & Wotton glass at the Old Neptune.

Peter O'Toole

The pub was again rebuilt, with many of the original timbers recycled, and that is pretty much the Old Neptune we have today, sloping this way and that in a decidedly Dickensian manner. It suffered in the great 1953 flood but this time stood firm, and today it stands proudly on the beach surrounded by a low concrete wall designed to offer some protection from the waters.

For many years the pub was owned by Ramsgate's Tomson and Wooton brewery, and you can still see some lovely etched glass windows advertising the fact, unlike at the Prince Albert in Sea Street where similar pieces of pub livery were sadly removed. In the 1960s, Whitbread had acquired both Tomson and Wooton and also Maidstone's famous Fremlin's, and certainly on my first visit to the Neppy in the very early 1990s I downed a pint of the latter's famous Kent bitter. The Old Neptune has been a Shepherd Neame pub since 2013.

In 2007, scenes for the Oscar-nominated film *Venus*, starring Peter O'Toole, were shot inside and around the pub. On one occasion O'Toole, a noted hellraiser in his day, stood the entire pub a round of drinks.

When the veteran actor died in 2013, many a glass was raised in remembrance at the Old Neptune.

THE BLACK DOG, High Street

The Black Dog, which opened its doors for the first time in September 2013, was Whitstable's second micropub after the Tankerton Arms but the first to be located in the town centre itself.

Occupying premises that were formerly Olivia's delicatessen, the man behind the venture was former photographer Mike McWilliams, who like many before him, and no doubt many to come, was inspired by Martyn Hillier's ground-breaking Butcher's Arms in Herne, the very first micropub.

However, while the Black Dog carries a fine and ever-changing range of cask ales and artisan ciders, and is typically compact within, it does differ in several ways from the micropub model pioneered by Hillier.

For starters, music – recorded and occasionally live – is played here, which is a strict no-no as far as Hillier is concerned. McWilliams also opens throughout the day with hours that are in line with conventional pubs, which once again is very much the exception as far as Kent micropubs are concerned. This, no doubt, is because of the Black Dog's prominent High Street location.

The Black Dog's quirky frontage is mirrored in its interior.

The Black Dog was Whitstable's second micropub.

A Touch of Gothic

Another thing which sets the Black Dog apart from most other micropubs is the interior, which has clearly involved some thought and effort. The long, narrow room is dark, and the overall feel is a mixture of Gothic and surrealism with various pieces of absurdist art and bizarre artefacts giving the place a unique atmosphere, part Victorian

Conversation and ale inside the Black Dog.

funeral parlour and part teenager's bedroom. If Harry Potter ever opened a micropub, it might look something like the Black Dog.

The pub also features a traditional bar with traditional handpumps, although these are purely for illustrative purposes and once you order your pint it will be poured direct from the cask in the cold room to the rear. It's good beer too, and the pub has already made it into the hallowed pages of *CAMRA's Good Beer Guide*.

Some are predicting that the micropub bubble is set to burst, but at a time when many conventional hostelries are finding the going increasingly tough, it doesn't look like this will happen any day soon. The Black Dog is a busy and essential watering hole that has added a new dimension to Whitstable's drinking scene while also managing to fit into the town's reputation for good, locally sourced produce. McWilliams told the *Whitstable Times* back in 2013, 'We want to be to real ale and cider what Wheelers is to seafood and the Cheese Shop is to fine cheeses.'

THE TWELVE TAPS, High Street

For many years, drinkers in Whitstable have been spoilt for choice when it comes to cask ales and more conventional keg beer offerings, but until the Twelve Taps opened for business in the High Street craft beer had a mysteriously low profile in a town known across the country for being 'on trend'.

The Twelve Taps is Whitstable's 'only dedicated craft beer bar'.

Opened in March 2016, and proclaiming itself to be Whitstable's 'only dedicated craft beer bar', the Twelve Taps was the brainchild of Becca Walton and business partner Libby Bradshaw, who previously ran Waltshaw's Kentish food store in trendy Harbour Street.

It occupies what was previously the Shangri-La Thai restaurant and, as the name suggests, features a dozen or so draft craft beers. They also serve wine, cider and gin.

Craft Beer Boom

A set definition of what exactly constitutes a craft beer has proved rather illusive to date, but, for the most part, they are heavily hopped keg beers brewed in small batches. However, as they grow in popularity, the volumes concerned are almost inevitably bound to change.

Although official figures show that in the United Kingdom overall beer sales are in slight decline, the growing popularity of craft beer shows no sign of slowing down. Indeed, as one of the fastest growing sectors of the drinks industry, craft beer has recently been added by the government to the 'typical' basket of goods used to calculate inflation.

The 'house' beer for the Twelve Taps is brewed by the Time and Tide microbrewery based in Deal, and they also carry brews from some of the growing number of craft brewers popping up all over the south-east, including Beavertown and the Kernel, who are both based in the so-called 'Bermondsey beer mile' in south London. All of which seems to confirm that, when it comes to the little matter of drinking beer, we do truly live in very interesting times.

SHIP CENTURION, High Street

The Ship is more than just a pub; for those with a CT5 postcode it's an institution. It doesn't appear in the Sunday supplements as often as the Old Neptune or the

The Ship Centurion is the quintessential Whitstable pub.

Sportsman, but for me it remains the quintessential Whitstable pub: welcoming, traditional, down to earth and just a little bit eccentric. The hanging baskets outside are almost as colourful as some of the customers within.

The current building dates from 1914 and was built by Ash and Co. of the Dane John Brewery in Canterbury, but there are records of an inn called the Ship on roughly the same site since at least 1750. *Ales and Tales* reckon it was originally built by Fenner and Flint, who would later evolve into Flint's of Canterbury. Ash and Co. acquired the pub in the late 1820s.

The Ship Centurion moniker was adopted in 1845 and is believed to have been inspired by the *Centurion*, the lead vessel of eight used by George Anson on his voyage around the world between 1740 and 1744, later immortalised in the 1748 book *Voyage Around the World*.

German Connection

The voyage, and of course the book, made Anson a popular national hero, especially as he had given the Spanish, with whom we were at war, a bloody nose in the process. The human cost was large, however. Of the 1,800 men who left England with Anson only 188 returned.

The pub's sign today features a ship's figurehead depicting a Roman centurion, most probably of the German Cherusci tribe. The pub's owner since 1995 has been the Anglo-German Birks family, who had previously run the old Bear and Key. For many years family patriarch Armin was one of Whitstable's larger-than-life characters, and many tributes were paid in November 2013 when he died suddenly. One local told the *Whitstable Times*, 'So sad, an icon gone.' Today the pub is run by his wife Janet and son Roland.

The Ship Centurion's intriguing pub sign.

The Germanic connection is also reflected in the food – on Saturdays schnitzel appears on the menu – and also the eclectic, and frankly wonderful, range of beer carried by the pub. In addition to a changing line-up of cask ales, also on tap are a number of German lagers and wheat beers. The pub has been a regular in *CAMRA's Good Beer Guide* for many years and in 2015 was named East Kent Pub of the Year by the local CAMRA branch.

The Ship is a gregarious and bustling place where banter flows as readily as beer. Live sport is shown on a number of screens, and it is a popular post-match destination for at least two Whitstable Town FC supporters.

THE PETER CUSHING, Oxford Street

Over the years the J. D. Wetherspoons pub chain have made the conversion of former banks and cinemas into something of a fine art, but there can be few hostelries in their empire to match the Peter Cushing for sheer splendour, elegance and opulence.

The pub opened in Oxford Street in the summer of 2011 and is located in what was until the mid-1980s the Oxford Cinema. Until Wetherspoons acquired the building, it housed a bingo hall. The conversion in this case did not come cheap, and in total the pub chain spent some £1.6 million on the project, the discovery and removal of asbestos adding to the final bill.

There was, however, much controversy over their choice of name. Although in recent years a number of moderately famous people have become associated with Whitstable, the person most strongly linked with the town, even more than twenty years after his death, is English actor Peter Cushing, star of many Hammer horror films, not to mention the very first *Star Wars* movie.

The Peter Cushing is named after the famous actor, a former resident of Whitstable.

Cushing and his wife Helen moved to Whitstable in 1959. It was a place where they were made to feel welcomed by the locals while at the same time allowed their privacy. The sight of Cushing cycling around the town was a common one and was immortalised in the song *Peter Cushing Lives in Whitstable*, recorded by The Jellybottys.

Controversy

But despite Cushing's popularity in the town, the choice of name for the new pub was not universally liked with many preferring a number of other suggestions, among them the New Oxford and the Magic Lantern, both inspired by the building's former life as a cinema.

The Oxford Cinema opened for business on 27 July 1936. The bill that night included a short film called *Last of the Pagans* ('A beautiful Romance of the South Sea Islands', according to the programme) and 'A Coloured Cartoon' entitled *The Good Little Monkey*. The main feature was *Jack of All Trades*, starring Jack Hulbert.

The interior of today's pub is a pretty decent stab at recreating an Art Deco cinema of the 1930s. The main, rather cavernous bar boasts four spectacular hanging lamps while a huge image of Cushing, in a scene from one of the Hammer Horror films that made him a star, looks down over proceedings from behind the bar. The cinema effect is completed in the foyer by a collection of old projection equipment and some stunning vintage film posters.

Quite what Cushing would have made of the whole business is anyone's guess, for he was a modest man, but the pub named in his honour remains a handsome place to eat and drink and, thankfully, avoids any hint of tackiness.

COACH AND HORSES, Oxford Street

Like many of Whitstable's oldest pubs, what is now the Coach and Horses originally started life as a cottage, in this case the end building in a row of cottages. There's a good chance ale was sold from the building for many years prior to 1830, when it was granted its first licence.

As the name suggests, the pub would have been a popular stopping point for horse-drawn traffic heading in and out of Whitstable, and there would at one time have been extensive stabling facilities to the rear. The interior of the pub itself would have been divided into a number of separate drinking areas, including a snug, although it is essentially an open plan affair these days. The pub was also once famous for its rather grand skittle alley, although sadly this has long since disappeared.

Certainly by the 1850s, the Coach and Horses name was featuring in local directories, and it has remained a popular town hostelry ever since.

Sale at Auction

During the 1880s, brewer Shepherd Neame started to expand beyond their Faversham base and acquired a number of pubs in Whitstable, including the Coach and Horses. There are records showing that Percy Neame, the first of the Neame family to be involved with the Faversham company, attended an auction at the old Bear and Key

The Coach and Horses, Oxford Street.

The Coach and Horses is a popular live music venue.

hotel in 1882. He paid the grand sum of £420 for the Oxford Street pub, and it has remained a 'Sheps' house ever since.

The longest serving landlord at the Coach was Percival Humphrey, a popular local figure who was behind the bar from the early 1920s right through until 1962.

Despite a facelift undertaken by Shepherd Neame a few years back, the pub remains distinctly old school in look and feel. It is Grade II listed and retains bags of character, sagging and leaning and as cosy as your favourite old cardigan. The pub is also a popular music venue and stages regular live folk and blues events.

THE EAST KENT, Oxford Street

Although the Canterbury and Whitstable Railway connected the cathedral city and the coast from 1830 onwards, giving it a good claim to be the first regular passenger train service anywhere in the world, a rail connection to London wasn't established until 1860. But when it did arrive, the good people of Whitstable certainly made the most of it.

Today, Whitstable station is somewhat off the main drag, and a good five-minute stroll into the centre of town, but originally the station was located on the bridge that today marks the point where Oxford Street, Belmont Road and Canterbury Road converge. It would remain here until 1914.

The East Kent, Oxford Street (Shepherd Neame).

With one eye on the trains soon to arrive, not to mention the passengers and custom that would come with them, a number of enterprises opened nearby, chief among them the East Kent in Oxford Street, or East Kent Tavern as it was known at the time.

An alehouse had stood here since 1802 when John Saunders, owner of the old Whitstable Brewery, built a pub. But the grand hostelry that emerged to serve thirsty railway customers and staff was a different proposition altogether, an elegant building with double-fronted bay windows that was opened for business sometime in 1860. It's been with us ever since.

Red Caps Give Chase

Today's Whitstable Brewery, incidentally, is based at Grafty Green, near Maidstone, but Mr Saunders's business was based in the town itself in Oxford Street, roughly opposite where today's library can be found and just yards from the East Kent itself.

For many years after opening the East Kent was used to stable the horses of carriage drivers who would take passengers onwards once they had arrived in Whitstable by train.

A story is told in *Ales and Tales* of a Whitstable man, George Harman, who during the First World War was on the run from the Military Police. While being pursued he apparently ducked into the East Kent, disguised himself as a carriage driver and promptly made his getaway, a yarn that could have come from the pen of John Buchan.

The East Kent has long been a Shepherd Neame house (Shepherd Neame).

Pub sign honours the Royal East Kent Regiment, the 'Buffs'.

The pub was a hotel for many years, as a surviving cut-glass window proclaiming 'Coffee Lounge' confirms, and since the 1880s has been owned by Shepherd Neame.

Although the pub was originally named to mark the arrival of trains from London into East Kent, for many years the pub sign has featured the crest of the Royal East Kent Regiment, also known as the Buffs.

HANDSOME SAM, Canterbury Road

Opened in November 2014, the Handsome Sam is the most recent micropub to open in Whitstable. Situated just under the railway bridge heading out of the town, right at the start of Canterbury Road, it's a welcome addition to the town's watering holes in a part of Whitstable which can seem a little forlorn at times.

The man behind the venture is Chris Williamson, who gave up his job as a radiology manager at the Kent and Canterbury Hospital to pursue the micropub dream.

The pub is situated in what was previously Dales Furnishing shop, and it was the location that initially persuaded Williamson to take the plunge.

'This place jumped out at me as I drove past,' he told the *Whitstable Times*. 'It's the perfect spot for a pub. It's got beautiful beams and is full of light. It's got a real charm and character.'

The Handsome Sam, Canterbury Road.

Top Cat

Williamson decided to name his new venture after Sam, his much-loved feline companion who passed away in 2010. In a weird piece of synchronicity the pub opened its doors for the first time on the fourth anniversary of Sam's death.

Sam's image, almost Warholesque in its black-and-white simplicity against a vibrant red background, features as the pub's logo and is also on its beermats.

Like the majority of micropubs, and in keeping with the ethos of Martyn Hillier's groundbreaking Butcher's Arms in Herne, the Handsome Sam frowns on the use of mobile phones to encourage conversation and is also music-free. There are also no television screens, although Williamson did break with this particular micropub convention for the 2016 Six Nations rugby tournament, and his establishment was even busier than usual as a result.

The beer, usually a range of four different cask ales often sourced locally, is immaculately kept and dispensed from a temperature-controlled room cunningly concealed behind what Williamson refers to as the 'beer tent'.

The Handsome Sam is just yards from what was once the Railway Inn, on the corner of Canterbury Road and Belmont Road. Beer had been sold here since the late 1840s, and it prospered when the railway came to Whitstable for the old Whitstable station

was on the bridge that marks where Oxford Street and Canterbury Road meet. The pub finally closed in the 1970s and is now a private residence. It features in Somerset Maugham's partly autobiographical *Cakes and Ale*.

TWO BREWERS, Canterbury Road

With some justification the Two Brewers in Canterbury Road claims to be the oldest surviving pub in Whitstable, and that's quite a thing to boast about as records show there was an inn established on this site as early as 1720, a substantial brick building which replaced a smaller cottage. The same brick building forms the bare bones of today's pub.

Canterbury Road, leading on to Borstal Hill, was the main road out of Whitstable towards Canterbury, but in the eighteenth century when the Two Brewers first opened its doors, it would have been positively rural compared to today's constant stream of traffic. Messrs Pike, Page and Cann in *Ales and Tales* tell us that an 'ancient trackway' came up from the shore near the pub and followed on to Duncan Down, and also that the annual Dredgermen's Fair was held near the pub until 1850. It was clearly, then as now, a busy meeting place.

For many years the pub was owned by Flint and Co. of the St Dunstan's Brewery in Canterbury, who owned several other taverns in the town. The two front windows of today's Two Brewers still feature rare surviving etched glass advertising Flint's 'Canterbury Ales, Stout and Porter'.

The Two Brewers is one of Whitstable's oldest pubs.

Thespian Landlord

The pub has had many landlords over the years, but without doubt the most colourful was Arthur Bertram, who took on the Two Brewers in 1923 and is recorded as its landlord from 1930 onwards. Previously he had spent more than thirty years working in theatre management, mainly in London.

Local historians seem to agree that Bertram followed the famous Irving family down to Whitstable after working, and building up a friendship of sorts, with the great Shakespearian Sir Henry Irving.

The Irvings had acquired the old Borstal Hill Mill, or Black Mill as it was also known, some years earlier, and in 1828 Sir Henry's grandson Laurence Irving converted it into a studio. The mill still stands today and, now a private residence, is as striking as ever.

Bertram remained 'mine host' at the Two Brewers for many years, certainly into his eighties, and died in 1955, aged ninety-five.

Without doubt one of the highlights of Whitstable's varied cultural life is the weekly afternoon residency of Burt Butler's Jazz Pilgrims, which takes place amid scenes of good old-fashioned hedonism and foot stomping at the Two Brewers every Friday.

This famous residency, something of an institution in Whitstable, took place for many years at the Duke of Cumberland. But when a new management team took over the High Street pub it came to an end, and Burt, his band and their devoted army of fans headed south. The Duke's loss is very much the Two Brewers' gain.

Pub sign for the Two Brewers.

The Long Reach.

THE LONG REACH, Thanet Way

The current Long Reach, formerly the Long Reach Tavern, opened for business in 1936. It was built by Mackesons, the famous old Hythe brewer responsible for giving the world Mackesons Milk Stout. By that stage in the company's history they were actually owned by the London giant Whitbread.

This grand and large public house, built in the 'roadhouse' style popular at the time, took its name from the old Long Reach, which was a rather more modest affair located on Borstal Hill.

By all accounts it did not enjoy the best of reputations, and its customers, according to *Ales and Tales*, included 'poachers and the roughest class of people in Whitstable'.

In 1935, Mackesons called last orders on the pub, and the following year the name once again appeared, now transferred to the spanking new pub located alongside the recently opened Thanet Way.

Roadhouses Galore

The rise of the roadhouse style of pub coincided with the boom in British motoring. As cars became more affordable, and as new roads opened all across the country, a number of these large public houses sprung up to tap into the potential new market.

By the standards of the day these pubs were often upmarket places – or at the very least places with upmarket pretentions – in an attempt by the brewers to also appeal to female customers.

There are several surviving roadhouse-style pubs in East Kent, and in addition to the Long Reach, the Plough and the Wheatsheaf, both in Swalecliffe, are of the

The Rose in Bloom, Joy Lane.
(Picture courtesy of Lydia Homer)

genre. The idea of driving to a pub and then driving home again, probably after liquid sustenance, is rightfully frowned upon these days but not so it seems in 1930s.

Originally, the Long Reach struggled to attract custom, and its future was at one time in doubt. But the years after the Second World War were the golden age of the pub beano, and Margate was one of the most popular destinations for these often riotous pub outings. Certainly the many coaches, or charabancs, full of thirsty Londoners looking for refreshment and perhaps the lavatory came to the pub's rescue, and it has been with us ever since.

In 1980s, the building was extended and remodelled, losing much of its roadhouse charm in the process, and for many years has been part of the Beefeater chain of pub restaurants. These days there is also a large Premier Inn hotel to the rear. Both are owned and run by Whitbread.

ROSE IN BLOOM, Joy Lane

If you don't quite feel up to the walk from Whitstable to the Oyster Pearl or the Sportsman out at Seasalter, the Rose and Bloom offers an alternative. It is located in Joy Lane, and you can yomp most of the way from Whitstable along the beach. That salty sea air is bound to give you a thirst.

The Rose and Bloom started life around 1860 as a simple but well-appointed weatherboarded cottage, little more than a beerhouse, looking out over the estuary's moody mudflats. It was a popular haunt of the local smugglers who thrived in these

parts and took its name from a well-known local fishing vessel, one of the famous Bawley style of boats that would have operated in the ancient Pollard oyster beds, once owned by the Dean and Chapter of Canterbury no less.

Stephen Hunt is the first recorded licensee here, and he seems to have got into a spot of bother in 1860 when he was charged with selling ale outside of permitted hours on a Sunday. However, the evidence against him was obviously not strong enough and the case was dismissed.

Pub Rebuilt

In 1898 the famous old brewer Mackeson's of Hythe acquired the pub, and they set about building the solid brick tavern that we have today. At the same time the former cottage alehouse premises were sold off as a private residence, which was named Treetops – which seems rather apt given the site's elevated position. This was demolished at some point in the 1930s, and today's Rose and Bloom car park stands on the site.

In the early twentieth century Mackeson's were bought out by Whitbread, who acquired a number of pubs throughout Kent, not to mention the famous Milk Stout, and for many years the Rose and Bloom remained under the control of the giant London brewer, who were well represented in the area until they sold off most of their tied pub estate in the early twenty-first century. The pub is now in the hands of Enterprise Inns.

Today the Rose and Bloom benefits from both its wonderful location – which in addition to the Thames Estuary offers views of Sheppey and, on a clear day, Southend – and its reputation for good beer and food, boasting a separate bar and dining area. It's also an excellent place from which to toast Whitstable's famous sunset.

THE OYSTER PEARL, Faversham Road

Smuggling thrived along much of the Kent coast throughout the eighteenth century – indeed into the early nineteenth century – and it was particularly prevalent in Seasalter, then a small, largely lawless and isolated village distinct from its wealthier and bigger neighbour Whitstable.

It isn't surprising, given the geology and the geography of the place, that smuggling was so prevalent. The shore here is soft shingle and mud, ideal for landing boats, while the open marshland close by meant that smugglers, with an intimate knowledge of the area, could easily lose any pursuing law enforcement officers.

And then of course there were the pubs, eager to play their part in the smuggling merry-go-round, pubs like the old Blue Anchor, which since 2013 has been trading as the Oyster Pearl.

There has been a place of refreshment and refuge here for more than 250 years, starting with the Crown around 1744, which in turn became first the Rose and Crown, the Anchor and eventually the Blue Anchor, a procession of name changes that occurred during the 1750s.

Another reason smuggling thrived in these parts is that almost everybody was involved in it, from the eccentric local Reverend Thomas Patten through to the

The Oyster Pearl was a former haunt of smugglers. (Picture courtesy of Lydia Homer)

various landlords of the Blue Anchor including John Codham, who had an early and long-standing association with the place.

Gastropub

The Blue Anchor was acquired by the Faversham brewers Rigden's in 1811 (by this time smuggling was in decline), and it was still under their control in the late 1920s when an advertisement in the *Whitstable Times* announced that it was 'under entirely new management'.

The pub building we have today, rebuilt courtesy of Rigden's, is late Victorian and ever so slightly Gothic in appearance. Despite a huge caravan park directly opposite and a 1960s ground-floor extension, it still seems to fit its barren yet strangely beautiful surroundings perfectly.

In 2013, after more than 250 years as the Blue Anchor, the pub was given a major overhaul and the name changed to the current Oyster Pearl. It is as much a gastropub as a pub these days, and while it has picked up awards for its food, one imagines it will live for many years to come in the gastronomic shadow of its revered (and Michelin-starred) neighbour the Sportsman a short distance along the Faversham Road.

Having said that, it's certainly a pleasant place to quench your thirst after the long and bracing walk from Whitstable. And these days the place is guaranteed to be a smuggler-free zone.

The Oyster Pearl, Seasalter. (Picture courtesy of Lydia Homer)

The Sportsman at Seasalter has a Michelin Star. (Shepherd Neame)

THE SPORTSMAN, Faversham Road

Today the Sportsman at Seasalter is a destination gastropub that attracts diners who travel from near and far to eat Michelin-starred food cooked using locally sourced ingredients. But it wasn't always so, and for much of its long history this isolated old pub was more commonly frequented by smugglers than by *Guardian*-reading foodies.

The first official record of a tavern on this site dates from 1798 when Faversham man Thomas Woolley was granted a licence to sell ale, although it's likely that an alehouse of one sort or another was based here as early as 1642. Given the pub's remote location close to the Thames Estuary it comes as no surprise that so much contraband probably entered and left through this place.

In 1888, the pub was acquired by Shepherd Neame, and it has been in the hands of the Faversham brewer ever since. The pub was for much of its history a popular location for shooting parties, who would seek refreshment after a busy day on the nearby marshes. This is most likely the reason behind the pub's name. It was originally called the Old Sportsman, although in the 1978 Shepherd Neame booklet *Abbey Ale Houses in the Heart of the Hop Country* the pub is named as Ye Olde Sportsman Hotel and was 'a house well known to yachtsmen and water-skiers'.

Last Battle

Seasalter was the location of what is widely regarded as the last battle to be fought on British soil. On 27 September 1940, drinkers in the Old Sportsman had their revels

The Sportsman at Seasalter. (Shepherd Neame)

rudely interrupted when a German bomber, a Junkers 88, came down on nearby Graveney Marsh after having one of its engines shot out by a Spitfire.

Among those drinking in the pub at the time were a number of soldiers from the 1st Battalion London Irish Rifles, and they quickly made their way to the downed airplane only to be greeted by machine-gun fire from the surviving German crew. After several minutes of shooting, the German crew surrendered and were taken prisoner.

In September 2010, to mark the seventieth anniversary of the 'battle', a plaque was unveiled at the Sportsman.

Brothers Phil and Stephen Harris took over the pub in 1999; since then it has become one of the most acclaimed eating places in the country. The Sportsman has held a Michelin star since 2008 and in 2015 was named the best gastropub in the United Kingdom.

Despite all of this it remains a remarkably down-to-earth pub in a very atmospheric setting. Indeed, the Sportsman once described itself as a 'grotty rundown pub by the sea', albeit a 'grotty rundown pub' with a Michelin star.

Chapter Two

Chestfield, Swalecliffe and Tankerton

MONUMENT, Church Street
On the website for All Saints church, the area in and around Church Street is described as 'the village in the heart of the town'. For me, that's a spot on description of a neighbourhood that has a feel and identity all of its own, one very distinct from elsewhere in Whitstable.

The Monument is one of Whitstable's oldest pubs.

Opposite All Saints church itself, which is thirteenth century in origin and can still boast a Norman tower and Norman font with Tudor features, stands the Monument, which, as you might expect given the history in this quarter, is one of Whitstable's oldest surviving pubs.

The Monument Inn, as it was once known, was first licensed in 1731, which would certainly make it a contender for the title of Whitstable's oldest surviving pub. Like many of our oldest pubs, it would have started as little more than a dwelling where ale was available, although given its location it comes as no surprise to discover that it was next to, if not affiliated with, a forge and stables.

As you might expect with a pub of this age, the Monument has had many landlords down the years and been under the control of several different breweries. *Ales and Tales* tell us that in its early years the inn was run by a grocer from Boughton called William Loathis, although 'grocer from Boughton' does sound like the punchline from a rather corny joke.

Lively Landlord

John Hodges, who ran the pub throughout the 1860s, was clearly a colourful character with his own way of doing things. Records show that in 1863 he only had his licence renewed by the skin of his teeth, although he was warned about his future conduct.

It was a warning which seems to have fallen on deaf ears for the following year he was fined £1 8s for opening too early on the Sabbath. Despite these incidents, the Hodges family remained at the helm into the 1880s, with Hodges's widow and son running the shop after his death.

Ownership eventually passed, via a rather convoluted route, to Flint and Co. of the St Dunstan's Brewery in Canterbury and later to Beer and Co., also of Canterbury. It is, then, a sad reflection on the takeover madness that defined twentieth-century brewing in England that the Monument eventually ended up in the hands of Whitbread, one of the so-called 'big six' who between them almost levelled the regional brewing landscape in this country.

It is now in the hands of Enterprise Inns and seems to thrive as a popular community local, which is probably what it was back in 1731, although obviously without the Sky Sports. *Plus ça change* ... and all that.

THE MARINE HOTEL, Marine Parade

The very idea of Tankerton without the Marine Hotel sitting grandly atop Tankerton Slopes is preposterous, a bit like the Tower of London without its ravens. Two world wars and various changes of use over the years have not diminished its standing in the community. Most people, by and large, are rather fond of the Marine.

It was built in 1895, although originally not as a hotel. Next time you are in this neck of the woods stand in front of the Marine and consider the building before you carefully. You will clearly see that originally this was constructed as four separate, albeit very grand, terraced houses.

It was the work of the Tankerton Estate Company, then trying to develop the area into a rather upmarket residential suburb, and they pulled out all the stops with this

The Marine in Tankerton is a local landmark. (Shepherd Neame)

Marine Parade development. However, the expected growth of Tankerton was slow, and for many years these four houses stood isolated on Marine Parade sticking out rather like the proverbial sore thumb against the surrounding fields and bare plots of earth.

Hotel and Hospital

In 1906, two of the four houses were converted into a hotel. Throughout the First World War all four properties, as with what would eventually become the Royal half a mile or so east along Marine Parade, were converted into a military hospital.

After the Armistice of 1918, half of the building was returned to hotel use with the other portion remaining as a hospital, Whitstable's first by some accounts, until 1921 when it closed. In 1926, the entire building opened to guests, and the Marine Hotel, pretty much as we know it today, was born.

It has had a few ups and down over the years – haven't we all? – and, in 1993, *Ales and Tales* reckoned it had 'suffered something of a decline from its heyday'. However, for the last few years it has looked spick and span and very, very swish, courtesy of a £1.6 million refurbishment carried out by owners Shepherd Neame, the biggest job of its kind that the Faversham brewer had undertaken at the time. The old ballroom is now as elegant as it ever was, a popular venue for weddings and other events, while the bar, now as fresh as a daisy, still offers great views of Tankerton Slopes and Tankerton Bay beyond. On a clear day you can see the Maunsell Forts and can even try to count the wind turbines as you sip your pint of Masterbrew.

The main bar of the Marine, Tankerton. (Shepherd Neame)

This venerable old dame of a place is many things to many people. To some it is a pub that just happens to have a hotel attached. For visitors to Whitstable it's a hotel with a rather swanky bar. Either way, it remains a much-loved local institution.

TANKERTON ARMS, Tankerton Road

The Tankerton Arms, which opened in March 2013, was Whitstable's very first micropub. It was the brainchild of Nigel Ranger and his wife Patsy and was inspired, as indeed are most micropubs, by Martyn Hillier's groundbreaking Butcher's Arms in Herne.

Located in busy Tankerton Road, and occupying premises that formerly housed a tattoo parlour, the Rangers faced a slight delay in realising their dream when they had to wait for an ancient covenant that had forbidden the sale of alcohol on the site to be overturned. Once that happened, however, it was full steam ahead and they have been packed out pretty much ever since.

The micropub phenomenon started at the Butcher's Arms in Herne back in 2005 and saw Hillier take advantage of a relaxation in the licensing laws to convert a former and long-closed butcher's shop into a small alehouse. There was also no television, no music and no gaming machines. The use of mobile phones was also discouraged.

The Tankerton Arms, busy as usual.

Famous Name Revived

Perhaps the most significant thing about the Butcher's Arms was that it only sold cask ale, no lager. Indeed, Hillier was once famously quoted as saying, 'We don't sell lager. Beer has more hops which have a soporific effect. No one gets drunk in my pub, they get sleepy. The police have never been called to break up a fight at a micropub.'

Conversation and good beer are top of the agenda at the Tankerton Arms.

The Rangers, who live locally and are clearly historically astute, decided to revive the old Tankerton Arms name for their micro venture. The original Tankerton Arms was a pub occupying the ground floor of the old Tankerton Hotel. Both were built and opened by the Hythe brewer Mackesons in 1902 as the development of Tankerton – both as a residential area and a holiday destination – really got into full swing.

Both thrived until the Second World War, after which Tankerton as a resort went into decline. The hotel eventually closed with the upper floors converted into now much-sought-after apartments, going by the rather grand name of Tankerton Heights.

The Tankerton Arms pub continued for many years, standing on the corner of Marine Parade and Park Avenue and operating as a popular free house. However in the early 1990s it closed and, like the floors above, was also converted into flats. A surviving piece of original etched glass can still be glimpsed in Park Avenue.

The second coming of the Tankerton Arms, under the stewardship of the Rangers, is proving every bit as vital to the local community as the old pub from which it takes its name. The beer's rather good too.

THE ROYAL, Marine Parade

Although the Marine remains the area's best-known watering hole, just along Marine Parade the Royal, while much humbler in dimensions, has arguably played just as big a part in the development of the suburb of Tankerton.

The bare bones of today's Royal can be traced back to 1894. It was opened as the Pavilion by the Tankerton Estate Company as their saleroom and could hold up to 150 people at a time. A hotel block with some thirty rooms was built next door in 1899.

Development of the area that we today know as Tankerton started in the 1890s when the estate was acquired by a London businessman. He paid £16,000 for a considerable chunk of land with a view to create a new residential suburb in the rolling green fields to the east of Whitstable.

As early photographs reveal, however, the development was not an instant success, and so in a desperate attempt to sell plots of land, a slightly underhand method was adopted. Potential buyers – comfortably off, middle class and from London – were lured down to the coast and, before the scheduled auction, plied with free drink and rich food, the theory being that they would become more 'relaxed' and, perhaps, more likely to buy.

Herr Mohr

I dare say it worked occasionally, although not in the case of a certain Herr Mohr, as recounted in *Ales and Tales*. Mohr fell in with a salesman named Hudson, who promptly paid for his new friend to get the train down to Kent from London and, on arrival, to partake freely of refreshment before an auction.

The sozzled Mohr seems to have signed on the dotted line, and when he was later taken to court by the Tankerton Estate Company in pursuit of his unpaid deposit the judge ruled that the auction was perhaps not run as properly as it could have been. He also ruled in favour of Mohr, who no doubt celebrated with several stiff drinks.

Chestfield, Swalecliffe and Tankerton 55

The Royal has played a big part in the history of Tankerton. (Shepherd Neame)

The Royal, Tankerton, is a popular local. (Shepherd Neame)

During the First World War, several temporary military hospitals opened along Marine Parade, including at the Pavilion. The former hotel rooms next door were also called into use.

Once war had ended it continued as St John's Hospital until, in 1926, the nearby Whitstable and Tankerton cottage hospital opened. It was then the Royal Hotel from the mid-1930s, although it was closed in the run-up to the Second World War.

The former hotel is now private flats, while the former hotel bar houses the Royal, a comfortable hostelry with great views that enjoys a good reputation for its food while still serving as a cherished 'local' for those seeking a quiet pint – which, of course, is how it should be.

WHEATSHEAF, Herne Bay Road

It is hard these days to imagine Swalecliffe as a rural area once dominated by working farms, but both the Wheatsheaf and the Plough, the neighbourhood's two public houses that sit around half a mile apart, provide at least a reminder of a more bucolic past.

There are records of a 'beerhouse' here as early as 1830 when a local farmer by the name of Stephen Haliday started serving ale from a small cottage. Initially leasing the property, he acquired the freehold in 1840, and the Wheatsheaf first emerged as a tavern at around this time. Four years later it fell into the hands of the Canterbury

The Wheatsheaf, Swalecliffe.

brewer Ash and Co. based at the Dane John Brewery, which stood until 1936 on a site next to today's Dane John Gardens.

In the constant merger and acquisition activity that gripped the Kent brewing industry for much of the twentieth century, the pub was later owned by Hanbury and Co., the Wateringbury brewer with a family link to the once-mighty Trumans of London, and later still by Whitbread, another big London brewer who expanded their pub estate throughout Kent by buying and subsequently closing a number of regional brewers.

Haliday remained at the helm for at least some of these changes, and records show he was still behind the bar into the early 1860s.

Growing Popularity

The arrival of the railway in East Kent in the 1870s had already started to change the face of Swalecliffe, but the area's development into a suburb in its own right really gathered pace in the late 1920s and throughout the 1930s. The current Wheatsheaf pub was built in 1936, largely to cater for this growing residential population. It has been expanded since, notably by the addition of a conservatory.

The Wheatsheaf today is a sturdy old hostelry, functional in design and set back off the busy Herne Bay Road. Although it does boast a bar area, much reduced in the most

recent pub refurbishment, the emphasis these days is on food and, in particular, catering for families. As such it is part of the Hungry Horse chain belonging to Suffolk-based brewer and pub company Greene King.

Unfortunately, in the hands of Greene King the pub's glorious old sign, which once depicted a sheaf of newly harvested wheat, has disappeared and has been replaced by some rather garish corporate signage.

THE OYSTER BED, Thanet Way

The Oyster Bed opened in 2014, a newly built and almost identikit version of the 'rotisserie pub' model being rolled across the United Kingdom by Marston's, the giant pub and brewing concern that just happens to also be the world's largest brewer of cask ale.

Located just off the busy Thanet Way, close to the Chestfield and Swalecliffe roundabout, the pub itself is faux old world although the architecture, such as it is, is more toy town than Tudor.

The pub sits adjacent to branches of both McDonald's and KFC, and should you choose to sit outside, a twin-pronged assault on the olfactory senses is a distinct possibility.

Actually, the area outside holds some interest here because not only can you admire the trains shuttling to and from the nearby Chestfield and Swalaecliffe station, but the Swalecliffe Brook runs alongside the pub. This ancient watercourse runs from Long Rock through Swalecliffe and Chestfield all the way to Honey Hill in Whitstable. It gives us some idea of how rural this area once was.

The Oyster Bed is one of the area's newest pubs.

Oyster Free Zone

In the Oyster's Bed defence, it doesn't pretend to be anything other than what it is, which is a chain pub where the emphasis is on catering for families and getting them fed and watered as quickly as possible. To my mind there is nothing intrinsically wrong with that. Although this is a pub in only the loosest sense of the term and despite a good range of beer (as you might well expect from a Marstons' establishment), I can't imagine many people visiting the place to sit and sup a pint while contemplating the world, their navel or possibly the *Guardian* crossword.

Some people will have us believe that the Oyster Bed is the future of the great British pub – and it must be said that in a day and age where the general trend is for pubs to close down, it is always encouraging when a new one opens – but those selfsame people have probably never experienced the joys of a genuine community local or, for that matter, micropub.

Rather confusingly, given the pub's name, oysters don't feature on the menu, and no overnight accommodation is available. Apparently, the pub name is designed to 'reflect' the town's 'history and tradition'.

CHESTFIELD BARN, Chestfield Road

Although the village of Chestfield can trace its history back to at least the eleventh century – it is mentioned in the Domesday Book of 1086 – the well-to-do and leafy

The Chestfield Barn was formerly a tea room. (Shepherd Neame)

enclave we know today is largely a twentieth-century conceit, a 'garden city' of sorts as envisaged by George Reeves, who bought the old Chestfield Manor, totalling some 700 acres of land, in 1920 for £11,500.

However, the Chestfield Barn, the area's defining building, is one of the few remaining links to the Middle Ages. It now houses a pub, although this is a relatively recent use for a building that can boast bare bones, and possibly have wooden beams that survived from the fourteenth century.

The barn is believed to have been built as part of a complex of buildings which formed the centre of the old Chestfield Manor, which takes its name from the de Chestville family who once ruled the roost here.

While some surviving structures now house the pub, other buildings form part of Chestfield Golf Club. Although the club itself has only been in existence since 1924 – the brainchild of the aforementioned Mr Reeves, who had grand ideas for the area, including an aerodrome – they can lay claim to having the oldest golf clubhouse in the world.

Tea Rooms

What is today the Chestfield Barn pub was for many years the Barn Tea Rooms. In *The Kent Coast*, published in 1965 as part of Ward Lock's popular Red Guide series of books, it is described as 'a fine fourteenth-century barn, beautifully preserved by a private owner'. The book also tells us that it was 'furnished and equipped in a style appropriate to its age' and is 'now open for most of the year as a restaurant'.

The Chestfield Barn only became a pub in 1988. (Shepherd Neame)

Reeves, who is commemorated today by Reeves Way, was a staunch teetotaller and was adamant that there should be no public house in Chestfield. With this in mind one does wonder whether Chestfield Golf Club's bar was originally also an alcohol-free zone. It certainly isn't today.

The Chestfield Barn pub came into being in 1988 after an extensive and mostly sympathetic renovation of the building. Grade II listed, today it boasts an attractive exterior, complete with thatched roof and pleasant gardens. A roaring log fire features during the winter months. It has been owned by Shepherd Neame for many years.

THE PLOUGH, St John's Road

The Plough, today a substantial public house set back off St John's Road, is like the nearby Wheatsheaf – a reminder, in name at least, of Swalecliffe's long-gone rural past.

It would once have been a fairly humble beerhouse, taking up most of a small row of cottages, brick-built with some weatherboarding. The majority of its customers would have been farm labourers. Kite Farm was just across the road, and the earliest recorded landlord is one George Pout, whose family were themselves farmers and local landowners. The Pout name can still be seen on several tombstones in the graveyard of the nearby St John the Baptist church.

The famous old Canterbury brewer George Beer and Co., consumed in 1921 by Rigden's of Faversham, bought the humble and rather rambling alehouse at the turn of the twentieth century and some years later, shortly before the Second World

The Plough, Swalecliffe. (Picture by Harriet Homer)

War, built the rather imposing building we see today. By this time Swalecliffe had been transformed from an area dominated by agriculture to more residential and suburban use.

Demolition and Rebuilding

It was then called the Plough Hotel, reflecting the growing popularity of this part of Kent as a holiday destination. Even today, a sizeable proportion of the pub's customers are drawn from the nearby Seaview Caravan Park.

The new Plough was actually built directly behind the old Plough, which would have been on St John's Road itself, although this was little more than a country lane at the time. When the new Plough was ready for business, in November 1938, the old Plough was demolished and the extensive car park still with us today was built in its place.

Ownership of the Plough has changed hands several times since, and it belonged for a while from the early 1990s to Thorley Taverns, the small Kent pub chain based in Thanet.

For a time the Plough was, rather bizarrely, renamed Eddery's after Pat Eddery, the celebrated Irish jockey, and his picture adorned the walls of the bar. In his time Eddery, who died in 2015, rode three Derby winners and was champion jockey on no fewer than eleven occasions. However, to the very best of my knowledge he never visited Swalecliffe for a swift half at the Plough.

Chapter Three

Herne Bay

The Hampton Inn, pictured in 1920 (above) and today (below). (Shepherd Neame)

HAMPTON INN, Western Esplanade

Today stoic and standing alone at the end of windy Hampton Pier Avenue, the Hampton Inn is pretty much all that remains of the once-vibrant village of Hampton-on-Sea.

The pub itself, which was known for much of its early existence as the Hampton Oyster Inn, was established here in 1867 by Shepherd Neame. It stood opposite the newly constructed Hampton Pier, which was completed the year before in 1866 and was intended to tap into the growing commerce in the surrounding area attracted by the Herne Bay, Hampton and Reculver Oyster Fishery Company, which was active from July 1864 onwards. Previously a pub called the Beehive had stood here but was demolished to make way for the Hampton Oyster Inn.

Hampton-on-Sea was at that point a sleepy fishing village, but from the late 1870s onwards it grew under the auspices of the Hampton-on-Sea Estate Association, who aimed to turn it into an upmarket residential area and holiday resort, complete with its own bandstand.

Erosion and Destruction

It soon became clear, however, that not all was well in Hampton-on-Sea, and a long-time consequence of the construction of the pier was rapid coastal erosion. The state of affairs was not helped by the inland Hampton Brook that flooded easily, further eroding soil that was already unstable.

The result was that over time properties began to be undermined by the sea, and they were eventually demolished. By 1916 the village was abandoned. The sea had won, but the Hampton Oyster Inn had survived.

The Hampton Inn takes a battering, c. 1914.

One fascinating character who features prominently in the story is Edmund Reid. Born in Canterbury, Reid had led early CID investigations in London in 1888 into the Whitechapel murders attributed to Jack the Ripper. He had retired to Hampton in 1903, and at the time the sea was judged a safe distance from his house.

However, as the rate of erosion quickened, Reid, always an eccentric figure, began to campaign on behalf of the remaining residents while also profiting from the situation. From a wooden booth at the end of his garden, which he called the 'Hampton-on-Sea Hotel', he sold postcards, lemonade and 'rescued' artefacts from the fast-disappearing village around him. He remained in his house to the bitter end and was the last person to leave the village in 1916.

It seems almost inconceivable that Reid did not at some point cross the threshold of the Hampton Inn. He was no stranger to pubs and in the late 1890s had himself been landlord of the Lower Red Lion in the nearby village of Herne.

The Hampton Oyster Inn became the Hampton Inn shortly before the First World War and has also been known as the Hampton Pier Inn at times. Its isolated position means it offers excellent views of the Thames Estuary and Whitstable's famous sunsets.

THE HERON, Station Road

In my humble opinion, every railway station should have a pub in close proximity, and if you happen to alight at Herne Bay, or you need some Dutch courage ahead of the 16.32 to London Victoria, then the Heron next door in Station Road is your nearest port of call.

The Heron, Station Road. (Shepherd Neame)

I don't think I am being duly unfair when I write that the Heron is not the prettiest of pubs you will ever encounter, although since it first opened for business in June 1965 it has won some admirers for its rather functional appearance which, to my mind, is very 'new town'.

The reason we have the Heron at all is because in 1964 the Grand Hotel, after many years of struggle, finally closed its doors. First opened in 1899, and containing fifty rooms, it was built in anticipation of the holiday hordes that would one day descend on Herne Bay. While Herne Bay certainly enjoyed many years as a popular seaside resort, those anticipated hordes never really descended.

Grand Hotel

The Gothic pile you encounter today upon leaving Herne Bay station and turning right was the Grand. It is a striking old dame of a building and impossible to miss. Stand and admire and contemplate it a while. It is now St Mary's Court, a block of private flats that affords an excellent view of the local allotments.

Although the Grand was ultimately a failure, its bar was a popular local watering hole in a part of town that was otherwise a bit of desert as far as pubs were concerned. But when the hotel closed so too did the bar and the Heron was designed as its replacement.

Pubs close to railway stations tend to attract a lot of passing trade; it rather comes with the territory. But the Heron is also a popular local and runs a number of darts teams, while the decidedly Kentish game of bat and trap is played in the garden during balmy summer months.

In 1980, kitchen facilities were added and the saloon bar given a makeover. It has been a Shepherd Neame house since it opened and takes its name from the bird that features on Herne Bay's town coat of arms.

THE SAXON SHORE, Central Parade

While the Peter Cushing along the coast in Whitstable is a truly spectacular Wetherspoon pub, the Saxon Shore by contrast is a rather functional and drab place. But sometimes it's all about location, and the Central Parade setting is certainly one of the pub's saving graces.

Hospitality of one type or another has been offered on this spot since the 1890s when Collard's opened for business here. A 'family and commercial hotel' with dining rooms, it was the brainchild of W. Collard, a local carriage operator who had his stables located at the rear of the building.

This was a period when Herne Bay's status as a seaside resort was at its peak, with Victorians in search of sun, sand and fresh sea air making the journey to the town by both railway and steamer.

Unfortunately, Collard's suffered more than most in the great storm of November 1897 when much of the town was flooded. In the deluge many of Collard's horses had to be led to safety, but his favourite pony wasn't quite so lucky and drowned.

The Saxon Shore, Central Parade.

Grand Ballroom

The property changed hands several times in quick succession in the years immediately after the storm. It briefly became Leech's Parade, a restaurant, and soon after was trading as the Parade Restaurant and Tower Hotel. A concert hall was incorporated into the building in 1915, which was something of a local landmark on account of the rather grand tower on its roof. Despite its rather grand demeanour, the Tower Hotel was not averse to selling beer and made a point of advertising its range of 'Ind Coope and Co Ales and Stouts'.

This apparently rather elegant structure was destroyed by fire late in 1932 and was rebuilt the following year as a rather grand restaurant complete with art deco touches and its own ballroom, a huge space covering some 3,000 square feet. It was known at this time as Loader's Café and Restaurant and occupied much of the building that now houses the Saxon Shore.

But it seems that down the years few businesses were able to last for long in this particular location, and since the Second World War it has housed the Cardinal Restaurant and Ballroom, which claimed to be able to cater for as many as 1,000 customers at a time; Harvey's; and, for much of the 1990s, Chaplin's. When Chaplin's had their entertainment licence opposed by local police it was acquired by Wetherspoons.

The Saxon Shore opened as a pub in 1999 and takes its name from the 163-mile footpath that starts in Gravesend, Kent, and continues to Hastings in East Sussex.

DIVERS' ARMS, Central Parade

It is hard to conceive today when confronted with the manicured lawns and flower beds of Central Parade that this stretch of Herne Bay seafront was once a hotbed of smuggling. That often-violent past is reflected in a number of local pubs, prime among them the Divers' Arms.

The pub was built and opened in 1847 by William Hooper Wood, a local man with a fascinating and varied history. For many years Wood made a good living from the smuggling industry, but when the authorities finally caught up with him sometime in the 1830s, he was transported to Australia for five years.

Upon completing his sentence he somehow managed to find his way back to Herne Bay where he became involved in the diving industry, then in its infancy, by setting up his own company.

This area, and in particular Whitstable, was at the forefront of the development of diving technology. Brothers Charles and John Dean are widely credited with perfecting the first version of what would become the diving helmet, which was trialled in Whitstable, and certainly Wood was in the right place at the right time to make his fortune. One story is that his share of silver dollars recovered from a Spanish wreck off the Copeland Islands, north-east Ireland, paid for the construction of the Divers' Arms.

The Divers' Arms, Central Parade (Shepherd Neame).

Intriguing pub sign for the
Divers' Arms. (Shepherd Neame)

North Pole

There is another theory, however, that it was in fact the proceeds from his years of smuggling, kept safe for him during his incarceration, that funded the pub. If that's the case he couldn't have chosen a better location from which to cock a defiant snook at the authorities.

Today's Divers' Arms is a busy seafront pub with a reputation locally for staging live music. Inside you will find a treasure trove of diving nauticalia, including an old diving helmet that has been adapted into a collection box for the Shipwrecked Fishermen and Mariners Royal Benevolent Society. The inscription warns that, 'There is sorrow on the sea.'

The pub's exterior is painted a rather striking shade of what can only be described as Matisse blue, part of a major renovation carried out by Shepherd Neame, while the hanging sign features three old-style divers and a coat of arms. The Latin inscription *Dum Spiro Spero* translates as 'while I breathe, I hope', which sounds like sound advice to me.

Another sign points out towards the Thames Estuary. It reads, 'Did you realise? Follow this sign & tis only 2675 miles to the North Pole.' A pint or two of Masterbrew would surely be in order after such an arduous swim.

Old diving helmet at the Divers' Arms. (Shepherd Neame)

THE SHIP, Central Parade

The Ship is by some margin the oldest surviving pub in Herne Bay, and although records are a little hazy, it is widely reckoned that it was trading on its current site from the mid-seventeenth century. The pub itself claims a founding date of 1385, which seems unlikely.

The Ship, Central Parade, is Herne Bay's oldest pub.

The location of the pub is opposite a slipway where many trading vessels known as hoys would load and unload a wide variety of goods, and so it can claim to have played a big part in the development of Herne Bay itself as a trading town. It was certainly a place where many seafarers would have sought refreshment, hence the pub's name.

The white weatherboarded extension to the original pub was added in the early nineteenth century to cater for growing custom. With the threat of French invasion always a possibility throughout the Napoleonic wars, a gun battery and a large number of troops were stationed nearby, and where there are soldiers there will usually be a demand for ale, which the Ship was happy to meet.

The pub subsequently became a popular venue for major gatherings and was also used throughout the nineteenth century as a makeshift coroner's court.

Later still, once Herne Bay had transformed itself into a seaside holiday resort, the pub became the Ship Hotel. It belonged to the Rigden's brewery of Faversham and eventually became a Whitbread establishment.

Storms and Smugglers

Given its seafront position, facing almost directly on to the beach until the first proper sea defences were built in the 1860s, it has taken a bit of battering from the elements over the years, most notably during the great storm of 1897 and the great flood of 1953.

The pub was also at the forefront of the local smuggling trade that thrived along the Kent coast throughout the eighteenth and early nineteenth centuries. On 21 April 1821, almost immediately outside, a group of smugglers were intercepted and challenged by the Coastal Blockade Service, and in the ensuing melee a young officer by the name of Sydenham Snow was shot. Snow's pistol had jammed, and he had taken on the smugglers armed only with a blade. It was an act of immense bravery, one destined to end in tragedy.

Snow was carried inside the Ship Inn where his wounds were attended to by a naval doctor. However, three days later he died from his wounds. His grave can still be seen in the churchyard of St Martin's in the nearby village of Herne.

In 1987, Whitbread failed to win planning permission to undertake major works on the Ship, and after many years of struggle the pub closed in 2009. Thankfully, Herne Bay's oldest pub is now once again open for business and, considering its antiquity, looking very good for its age.

RODNEY'S SPORTS BAR, North Street

Despite sounding a little like an *Only Fools and Horses* theme pub, Rodney's Sports Bar can boast a history that goes back to the 1840s. North Street, a quiet turning between Charles Street and Mortimer Street, was formerly Donkey Green, and the Rodney's Head, as the pub was originally known, was built here around 1840, a 'quaint half-brick and half-timber' building squeezed into a row of small cottages.

It was named in honour of Baron George Brydges Rodney, or Admiral Rodney. A heroic naval officer, and by all accounts a rather dashing figure, his distinguished career included famous and emphatic victories against both the Spanish in 1780 and

Rodney's Sports Bar, North Street.

the French two years later. Even more than fifty years after his death in 1792, he was clearly still considered a suitable subject to have a pub named in his honour.

According to Michael David Mirams in his 1987 book *Kent Inns and Inn Signs*, the admiral's name became 'a by-word for hard drinkers'. These hard drinkers were, according to Mirams, sometimes called 'utter Rodneys'.

Rebuilding

In 1850, the pub was bought by the Canterbury brewer Flint and Co., and in the late 1930s, when much of this part of Herne Bay was the subject of major development work, it was decided to replace the old Rodney's Head, which was starting to show its age, with a spanking new structure.

What emerged was the building we have today, designed in the popular 'roadhouse' style of the day and by now in the hands of the famous Maidstone brewer Fremlins. For a period, the poor old Rodney's Head stood rather dejectedly as its brash replacement was slowly constructed next door.

The new Rodney's Head opened for business on 23 March 1939. One local newspaper of the day was moved to describe it as 'Georgian' in style. To this day it remains a handsome building, set back from the road and still with a little elegance about it.

The Jephcott and Crocker families, related by marriage, ran the pub from 1937 right through until the early 1970s. It has changed hands several times since and in 1998 was renamed Rodney's Sports Bar. It closed briefly in 2008 as a result of a dispute with neighbours over extended opening hours but was up and running again in time for Christmas that same year.

THE BOUNCING BARREL, Bank Street

Opening in May 2013, just a month after the Firkin Frog, the Bouncing Barrel was Herne Bay's second micropub. Located in what was once a shop selling baby clothes, it was the brainchild of husband and wife team Penny and Trevor Wicks and has already managed to be included in *CAMRA's Good Beer Guide*.

Trevor had long been an ale drinker and admired Martyn Hillier's revolutionary Butcher's Arms in Herne from afar. Once he crossed the threshold of the world's very first micropub however, he decided to open one of his own.

His wife Penny told the *Herne Bay Times*, 'Trevor has always been an ale drinker and every time we drove past the Butcher's Arms he said he wanted to go in. When he eventually did he came back and said we should open a micropub.'

'I scoffed at first,' continued Penny, 'and thought it was pie in the sky, but when he paid out for planning permission I knew he was serious and now I love it.'

The Bouncing Barrel was Herne Bay's second micropub.

Barnes Wallis

The pub adheres to the time-honoured micropub philosophy of limited opening times, intimate surroundings, no music and definitely no gaming machines. The use of mobile phones is also discouraged. Unlike many, however, it does open briefly on Mondays.

It is not uncommon for micropubs to adopt humorous and sometimes 'punsome' names, but while the Bouncing Barrel moniker initially appears comical, it is actually a reference to local history. The bouncing barrel of the pub's name actually refers to the bouncing bomb perfected by Sir Barnes Wallis to enable the RAF to launch successful raids during the Second World War on the many dams located in the industrial Ruhr Valley.

The local connection is that early versions of the bouncing bomb were tested just off the coast of Herne Bay. Indeed, a rather nice statue of Barnes Wallis can be seen in Herne Bay, located on Beacon Hill on the way towards Beltinge.

Whether Barnes Wallis was a drinking man himself is not on record, but I rather feel he'd have been more than happy to nip along to Bank Street for a pint of mild or two. He would certainly have appreciated a commemorative mural inside the pub, which has seating for twenty customers at a squeeze, that depicts a Lancaster bomber flying over the famous Reculver Towers.

Dambusters mural inside the Bouncing Barrel.

PRINCE OF WALES, Mortimer Street

There is a slight air of the gin palace about the Prince of Wales, which sits at the quieter eastern end of Mortimer Street. The current pub was built in 1902, so while certainly distinctly Victorian in style, strictly speaking it is much too late to be a genuine gin palace, but there are some nice surviving bits of gilt and etched glass to stir the imagination.

This is largely thanks to Graham Dash and his wife Enrica, who took over the pub back in 2001. In 2012, talking to the *Herne Bay Times*, Dash described the Prince of Wales as a 'proper pub, not a plastic pub'. Indeed, an estimated £40,000 was lavished on the old place, and they have even managed to keep the aspidistra flying.

It looks to have been money well spent as in 2007 the pub was named 'Best street-corner local' by CAMRA and in 2012 was voted East Kent Pub of the Year in a poll jointly run by a local media organisation in conjunction with Shepherd Neame.

A delighted Graham Dash told the *Herne Bay Times*, 'I am delighted with the award and even more delighted that it came from the customers. It's a great pub. It's nice to know the customers appreciate what we do.'

Hotel Heyday

There has been a pub on this site since at least 1870, although it was a far more modest building back then than its rather grand nineteenth-century replacement. A look up at the pub's exterior today will reveal its full name upon its 1902 rebuilding, for this was the Prince of Wales Hotel. The building itself is surprisingly spacious. In its hotel heyday guests would enter via a grand stripped canopy in East Street.

A busy session at the Prince of Wales. (Shepherd Neame)

The Prince of Wales, Mortimer Street. (Shepherd Neame)

One interesting episode in the pub's history, as detailed by John Fishpool in *Herne Bay's Hotels and Public Houses*, occurred towards the end of the First World War in 1918 and concerned the landlady, Mary Pullen.

Pullen, Fishpool tells us, was convicted of 'being in unlawful possession of army stores – namely a quantity of jam'. Having been found guilty by a local magistrate, the formidable Miss Pullen lodged an appeal and eventually had her conviction quashed, by the Home Office no less. His Majesty George V later issued a pardon to Miss Pullen. After all, she was the landlady of the Prince of Wales, Herne Bay.

DRUID'S HEAD, High Street

From humble beginnings around 1845, when it first traded as an alehouse, to the construction in 1879 of the rather striking High Street pub we have today, the Druid's Head has been one of Herne Bay's best-known watering holes.

Originally the Druid's Head was based in a terraced house just off the High Street in what is today Bank Street. It was described back then as a 'beershop'. Among the various landlords who ran it over the years was John Stephen Ells, who combined management of the pub with transporting mail for the post office between Herne Bay and Canterbury. He also used his fleet of donkeys, and even goats, to ferry railway and steamer passengers and their luggage around town.

The Ells family were still at the helm as late as 1887.

The pub was extended around the corner into the High Street in 1879, and the surviving part still in Bank Street looks to be the original terraced house of the 1840s.

The Druid's Head, Herne Bay. (Shepherd Neame)

Herne Bay

The difference in architectural styles between the two is certainly striking – the one functional and plain and the other much more flamboyant, ornate even.

Herne Bay Rocks

It has for many years been one of the town's best-known live music venues and was one of the original five pubs used to hold heats for the annual Herne Bay Rocks talent

Above: Main bar of the Druid's Head. (Shepherd Neame)

Right: Pub sign for the Druid's Head. (Shepherd Neame)

contest, which started back in 2006 and seems to go from strength to strength. Alas, two of the original five venues, the Hope and Anchor and the Queen Victoria, have since closed as pubs.

In 2010, the pub was the subject of the popular Pub Spy column in the local *Herne Bay Times* newspaper. The mysterious Pub Spy, whoever he or she was, concluded, 'If it's a no-frills, down-to-earth and unpretentious boozer you're looking for, then this is for you. Just take it easy with the pickled eggs.' Little has changed since.

Today the pub is distinctly old school and attracts a loyal bunch of regular customers. In a competitive marketplace, it looks as if the Druid's Head has staying power.

THE ROSE INN, Mortimer Street

Although the building on the corner of Mortimer Street and Little Charles Street that currently houses the Rose Inn dates from around 1835, it was only recognised as a pub proper in the late 1870s.

For many years No. 111 Mortimer Street was described as a 'house and shop', but it seems highly likely that it was a shop that at least sold beer. When it was taken over in 1863 by a prominent local man by the name of George Leadbetter, who had previously been landlord of the Druid's Head in the High Street, it was still not a fully licensed premises. Indeed, in one directory of the day Leadbetter is described as a 'beer retailer', which probably did not best please a man who had previously been in charge of one of the town's most prominent hostelries.

The Rose Inn, Mortimer Street.

Sadly, Leadbetter never got to see his 'house and shop' turn into a bona fide public house for he had been dead several years when, in 1879, the Rose Inn was finally recognised as a fully fledged public house, with his wife Hannah at the helm.

Colourful Exterior

It is, and seems to have always been, a typical local pub, the likes of which rarely get mentioned in dispatches. It came under the ownership of Shepherd Neame in the 1880s as part of their drive to acquire pub properties in both Herne Bay and Whitstable, and it remains with the Faversham company to this day.

Photographs down the years show that the pub has changed remarkably little in more than 130 years; its fine, painted exterior and colourful hanging baskets allow it to stand out against an otherwise drab streetscape.

One picture from the Shepherd Neame archive that is reproduced below shows clearly that the premises were indeed once a shop. The picture, from sometime in the late nineteenth century by the looks of it, also shows what appears to be the delivery of what, for a pub as compact as the Rose Inn, looks to be an enormous amount of beer.

It is an endearing image and a wonderful reminder of more innocent times when people sought pleasure away from the home and the government did not lecture its people about what is, or for that matter is not, a 'safe' amount to drink.

Beer delivery at the Rose Inn, late 1880s. (Shepherd Neame)

FOUR FATHOMS, High Street

The Four Fathoms is a grand old Victorian pile of a pub located at the High Street end of Station Road. Although it is a bit of a yomp from Herne Bay station, the pub started life as the Railway Hotel and first opened its doors to thirsty customers in 1868, although the bar extension into Station Road itself was probably a later addition.

The railway itself first arrived in Herne Bay in 1861, although initially the station was located near Greenhill. The current station opened in 1863 and for many years

The Four Fathoms, Station Road. (Shepherd Neame)

was known as Herne Bay and Hampton-on-Sea station. This was very much a boom period for Herne Bay (which was growing as a popular seaside resort), and many hotels were opened to cater for this influx of sunseekers.

In 1975, the Railway Hotel, which had longed ceased to offer accommodation, changed its name to the Four Fathoms. As any salty sea dog knows, four fathoms equals twenty-four feet, which is 'the depth of the deepest sea off Herne Bay', according to the pub website.

Refurbishment

Although the pub has changed landlords many times down the years, between 1954 and 1988 it was run successfully by Peter Smoothy with his wife, Shirley, and they were, by some margin, the longest-serving publicans in the area. Shirley's father James Davies had run the pub before them, from 1935 until his death in 1954.

The pub is something of a landmark in this part of Herne Bay, but, as is mentioned elsewhere in this book, times are hard for many traditional town centre taverns. The Queen Victoria, another once-grand old Bay boozer located a few minutes from the Four Fathoms, closed its doors for the final time back in 2013 and looks set to be converted into residential use.

Fortunately Shepherd Neame, owners of the Four Fathoms, decided that there is a future for the pub as a pub, and in January 2016 it reopened following a £210,00 refurbishment. In a nice nod to the pub's past, on hand to pour the very first pint was none other than Peter Smoothly, ninety-one years old at the time.

Former landlord Peter Smoothly pours the first pint at the reopened Four Fathoms. (Shepherd Neame)

He told the local *Herne Bay Times* newspaper, 'I was honoured to be asked to pull the first pint. I really enjoyed my time running the Four Fathoms. It is great to see Shepherd Neame investing in the pub as it is part of the town's history.'

THE FIRKIN FROG, Station Road

The Firkin Frog was Herne Bay's first micropub.

The Firkin Frog was the first micropub to open in Herne Bay. The Bouncing Barrel in Bank Street came a month or so later. Take my word for it, there will be more. Both were inspired by Martyn Hillier at the Butcher's Arms a few miles away in Herne.

The Frog, as is it known in this neck of the woods, was opened in April 2013 and has built up a loyal fan base since. This comes as a stark contrast to some traditional pubs in the town, a few of which have closed and face the almost inevitable fate of being turned into 'luxury apartments' or plumbing supply shops.

Steve Chandler was the man behind this venture, converting a former kitchen showroom into the micro we have today. From kitchen sinks to sinking pints, one might say. The Frog and Firkin sits almost directly opposite the Four Fathoms, a long-established Shepherd Neame pub. All things considered, Herne Bay is an interesting place for those wishing to observe the changing face of the British pub – and to watch, possibly, the future evolution of the British pub.

Good Beer Guide

As with almost every micropub you will ever encounter, and there will in all probability be one near you if not now then soon, the Frog and Firkin is very much a 'local' in the old sense of the term. This is a place for people to gather, drink good beer that is largely Kentish in origin, talk and put the world to rights. They have a regular quiz night here too.

It seems strange that a conurbation the size of Herne Bay, a place that clearly loves its beer, was absent from *CAMRA's Good Beer Guide* for several years. For the last two editions it has made a welcome reappearance, I am glad to report, with the Firkin Frog leading the charge.

Less than a year after opening, the Firkin Frog was voted 'Kent's best micropub' in a poll carried out by a local media organisation. The Butcher's Arms, oddly, didn't even make it into the top ten. Discuss.

Chapter Four

Beltinge, Broomfield and Herne

RISING SUN, Reculver Road

When the dear old Rising Sun closed, seemingly for good in 2014, it looked as if the village of Beltinge had lost what was, at the time, its only pub. We are of course all too familiar with stories of traditional 'locals' closing down, and as the boards went up on the windows of the 'Riser', it looked like a case of same old same old.

The Rising Sun in Beltinge.

However, this is a story with a happy ending and one which will warm your cockles, and it is all thanks entirely to the Whatley-Bates family. Beverley Whatley-Bates and her husband Roland had a strong local connection. For several years they had run the Waterways Caravan Park in nearby Reculver and hence knew Beltinge very well, but in 2010 they had moved to France.

However, when news reached them on the other side of the Channel that the Rising Sun was sitting empty and, in all probability, was about to be turned into flats or a restaurant or a betting shop, they decided they had to act.

Rescue and Reopening

In April 2015, Beverley told the *Herne Bay Gazette*, 'I've always wanted this pub so when the chance came up we had to take it. It would have been such a shame for it to close and die.'

'There are so many pubs closing down and we just didn't want that to happen here,' she continued. 'The customers are all local, and if it's closed there's nowhere left to go.'

Although Beltinge can now boast a second pub, the Copper Pottle micropub just across the road, it would clearly have been a crying shame for the Rising Sun, which is recorded here as early as 1847 when in charge was 'beer retailer' Harriet Sayer, to have closed, and as soon as the Whatley-Bates acquired the lease from owners Enterprise Inn, they gave the interior a complete revamp. Since reopening in April 2015, business has been brisk with daughter Holly installed as bar manager.

The Rising Sun is once more open for business.

It is also encouraging to see that, despite having a micropub located just yards away, the new Rising Sun has made a point of carrying a selection of cask ales sourced from many of Kent's thriving microbreweries, among them the excellent beers of Goody's of Herne and Gadd's of Ramsgate.

COPPER POTTLE, Reculver Road

At the time of writing, the Copper Pottle is the most recent addition to the Herne Bay and Whitstable area's rapidly growing number of micropubs. It was opened in Beltinge in June 2015, and the two men behind it are eminently well qualified to front such a venture.

Gary Pottle has a wealth of experience of working in the sports and leisure industry while his business partner Gavin Elgar spent no fewer than four years working for Martyn Hillier at the groundbreaking Butcher's Arms in the nearby village of Herne. The Butcher's Arms was the first micropub, opened in 2005, and has turned the pub scene on its head, initially on a local scale, although reverberations are now being felt across the country.

The Copper Pottle takes its name from Gary's surname and, apparently, the colour of Gavin's hair. Well, it makes a change from the Dog and Duck I suppose.

The Copper Pottle, Beltinge.

Micropub Ethos

The ethos of the micropub is to serve good-quality cask ale, much of it locally sourced, while also returning to the idea of the pub as a place where people can come to talk, untroubled by such twenty-first-century distractions as mobile phones, gaming machines or that newfangled television malarkey. Indeed, at the Copper Pottle mobile phones are 'outlawed'.

To emphasise the community angle, once a month the pub holds a charity night in which food is provided to accompany the beer and all proceeds raised are donated to the nearby Stroud Park Foundation, which helps people with disabilities and has been doing so for more than seventy years.

The Copper Pottle is housed in a former pet food shop and is typically idiosyncratic inside, where you will find bench seating and a ceiling decorated with upturned umbrellas. There is also a small beer garden.

The arrival of the Copper Pottle in the summer of 2015 means that the village of Beltinge now has two quality drinking venues, with the reopened and rejuvenated Rising Sun just across the Reculver Road. This is a very different scenario from the one that villagers were faced with just a few years back when it looked as if Beltinge would be left with no pub at all. To paraphrase Mark Twain, the reports of the death of the great British pub have been greatly exaggerated.

Interior of the Copper Pottle.

THE BUTCHER'S ARMS, Herne Street

When Martyn Hillier opened the Butcher's Arms in the sleepy village of Herne back in 2005, he both broke the mould and set in motion a revolution that has changed the pub landscape not only in Kent but throughout the British Isles.

The Butcher's Arms was the very first micropub, a 'pop-up pub' according to the esteemed beer writer Roger Protz.

As the name suggests, it is housed in a former butcher's shop, which closed in 1995, and the cold room to the rear that would once have housed sides of beef and mountains of pork chops is today a de facto pub cellar, with room for as many as eight casks of ale, with most of it sourced from microbreweries.

Hillier, clearly an enterprising chap with a passion for both real ale and community values, took advantage of a change in the licensing laws introduced in 2003 by the Labour Government, legislation that allowed for more flexible pub opening times and use of premises.

His micropub vision was one of a place where people could come to drink real ale, often from local breweries, in a convivial atmosphere free of the trappings one

The Butcher's Arms was the very first micropub.

It can get cosy at times in the Butcher's Arms.

associates with most modern pubs. So there is no television at the Butcher's Arms and no fruit or gaming machines. The use of mobile phones is also frowned upon. Conversation is the thing here.

Success Against the Odds

The pub interior itself is tiny and has room for ten people to sit and a further twenty to stand. Hillier reckons the most customers housed at any one time was thirty-seven. It was, he told trade paper the *Morning Advertiser*, 'like being on a London tube train'.

Despite having the Smuggler's Inn almost directly opposite, and the Upper Red Lion just across the road, the Butcher's Arms was an almost instant success, perhaps against the odds. In 2008, the Butcher's Arms was named Kent Pub of the Year by CAMRA, and indeed since Hillier has been in business, the poor old Upper Red Lion has closed.

There are now almost 200 micropubs across the country, and the pocket of East Kent that includes Herne Bay and Whitstable is something of a hotbed. Herne Bay, a couple of miles from Herne as the crow flies, now has three micropubs while Whitstable can boast the Black Dog, the Handsome Sam and the esteemed Tankerton Arms.

Hillier himself is more than happy to offer advice to those who dream of opening their own micropub, and he was instrumental in the formation of the Micropub Association. In 2015, Hillier was named Campaigner of the Year by CAMRA. Well deserved it was, too.

Micropub pioneer Martyn Hillier.

SMUGGLERS' INN, School Lane

Although it is located some two miles inshore on the way to Canterbury, the tiny village of Herne was once a hive of smuggling activity. It is commemorated today by the Smugglers' Inn, a pretty mid-Victorian building wedged in between some much earlier brick cottages.

Herne was where many of those involved in smuggling chose to live. Its location was, back in the day, remote enough to offer security when the authorities came calling, and an elaborate number of early warning methods, which included elevated windows in chimneys and the use of local windmills as signalling devices, meant that escape was usually possible.

Look closely today at the chimneys of some of the old cottages in Herne Street, facing St Martin's church, and you can still see the windows from which warning lights would have been displayed.

Although there is a certain air of romance attached by some to the history of smuggling, it could in reality be a brutal and bloody business as a wander around the

Smugglers' Inn, Herne (Shepherd Neame).

churchyard of St Martin's confirms. Here you will find the grave of young midshipman Sydenham Snow, who died from wounds suffered following an altercation with smugglers outside the Ship Inn, Herne Bay, in 1821.

There has been a tavern on the site of today's pub since the early eighteenth century, and there is little doubt that a large proportion of its customers would have had some involvement in smuggling.

Contraband Unearthed

This was confirmed in the late 1950s when the pub, then called the Prince Albert and in the hands of Ind Coope, was renovated. What workmen discovered, in addition to a spot of dry rot, was a number of hidden recesses, particularly in the pub cellar. Behind one wall were discovered some two dozen bottles of French wine, mainly claret but some Burgundy too, while buried beneath the cellar floor were a number of casks of rum, most of them full.

What happened to these casks in unclear. Was the appropriate duty paid on them, admittedly a little late in the day, or were they perhaps once again spirited away?

These discoveries led to the adoption of the current Smugglers' Inn name in 1959, and now in the hands of Shepherd Neame it has continued to play an important part in village life ever since. The ancient Kent game of bat and trap is still played in the pub garden.

Inside the Smugglers' Inn (Shepherd Neame).

HUNTSMAN & HORN, Margate Road

Broomfield, a mile or so from neighbouring Herne Bay with the roaring traffic of the Thanet Way effectively dividing the two, is a pleasant village that has a picturesque pond at its spiritual, if not geographic, centre. Overlooking this pond, on the corner of Margate Road and Pond Cottages, is the Huntsman & Horn, ideally placed at the very hub of village life.

The pub is certainly old and records show that the Huntsman & French Horn was here as early as 1739. The original surviving building is Grade II listed. In a conservation area appraisal produced by Canterbury City Council back in 2007 it is described as having a 'double gable Kent peg tile roof', and who am I to argue with Canterbury City Council? The appraisal goes on to say that 'the mix of old and new windows and surrounds of tarmac jar slightly with the rural setting of the pond'.

Despite this, it remains a handsome building in an understated way, a classic country village pub in look and feel both inside and out.

Village Asset

No one is entirely sure when the pub became the plain old Huntsman & Horn – during one of our many wars with the French one assumes. The name is certainly a bucolic reminder of a time when Broomfield, Herne and the surrounding areas were very definitely rural and the hunting of poor old Raynard very definitely took place.

The Huntsman & Horn, Broomfield's last pub.

The pub has been under the ownership of a variety of brewers over the years. It was a Rigden's house from 1854 onwards and, by dint of merger and takeover, eventually passed into the hands of Whitbread. Today it appears to be part of the Pubmaster stable of pubs and enjoys a good reputation for modestly priced food.

The Huntsman and Horn appears to be a valuable village asset, but if you do pop in for a quick one please spare a thought for the nearby Plough. Historically Broomfield's other pub, it was at the time of writing closed and has a very uncertain future.

It seems baffling that, at a time when the population of Broomfield and the surrounding areas continues to grow rapidly, a pub should close due to, one can only assume, a lack of customers. So cherish the Huntsman & Horn, good people of Broomfield; the message is clear: Use it or lose it.

Acknowledgements

There are quite a few people without whom this book would have been much harder to write and put together. I would like thank John Humphries and his team at Shepherd Neame for allowing me to use some of their photographs. I would also like to say a big thank you to numerous landladies and landlords, among them Nigel and Patsy Ranger at the Tankerton Arms and those fine upstanding people at the Copper Pottle in Beltinge. Much of the research for this book was done 'on the ground', as it were, and also in several of the area's excellent, if underfunded, libraries. I must, however, mention two titles that also proved invaluable. One is *Ales and Tales*, written by Messrs Geoffrey Pike, Mike Page and John Cann and published in 1993 by the Whitstable Improvement Trust. The other is *Herne Bay's Hotels and Public Houses*, written by John Fishpool and published in 2009 by Pierhead Publications. Most of all, however, I would like to say a big thank you to my daughter Harriet, if for no other reason than she is funny, beautiful and my daughter, and to my wife Lydia, who once again stepped up to the plate to help out with proofing and photographic duties. As ever, *Altiora petimus*.